Praise for *Girl with Death Mask*

"Jennifer Givhan, we're awed by your use of pause and
pacing, as you lead us to better understanding a woman's
landmine-filled journey out of childhood."

—*ForeWord Reviews*

"Givhan crafts a clear-eyed narrative of Latina womanhood in
this lovely collection ripe with longing, hope, and broken faith.
. . . She explores the dark sides of adolescence and womanhood
with searing imagery and a healthy dose of empathy."

—*Publishers Weekly*

"These poems beautifully, convincingly do what I hope poems might—they disrupt what I know, or what I thought I knew. And in that way they invent for me a world. A world haunted and brutal, yes. But one mended, too, by the love and tenderness and vision and magic by which these poems are made. Again and again I found myself looking into space, sort of shaken, sort of grasping, turning and turning inside a line or phrase, inside an image or metaphor, inside some devastating music."

—Ross Gay, author of *Catalog of Unabashed Gratitude*

"Magic, alchemy, transmogrification, and the body's deep obsessions fill these lyrically charged poems with an unearthed power. Givhan is a poet who knows the bones of her own world so well that she can rearrange them into anything she wishes. Both surreal and rooted in truth, the complex and gorgeous poems in *Girl with Death Mask* continue to shake, stun, and weave their spells long after the book is closed."

—Ada Limón, author of *Bright Dead Things*

BLUE LIGHT BOOKS

What My Last Man Did
Andrea Lewis

JENNIFER
GIVHAN

Girl with Death Mask

Indiana University Press

This book is a publication of

Indiana University Press
Office of Scholarly Publishing
Herman B Wells Library 350
1320 East 10th Street
Bloomington, Indiana 47405 USA

iupress.indiana.edu

Cataloging information is available from the Library of Congress.

ISBN 978-0-253-03279-9 (paperback)
ISBN 978-0-253-03280-5 (ebook)

1 2 3 4 5 23 22 21 20 19 18

Contents

III

IV

Acknowledgments

My love and gratitude to my family, most specifically the women and girls—my mom, Dr. Suzanne Casas Boese, and daughter, Adelina Suzanne Givhan. This book is for you. I'm thankful for my faithful poetry sisters and lifelines Avra Elliott, Alicia Elkort, Stacey Balkun, and Stephanie Bryant Anderson, who read draft after draft of each poem, even as the punctuation became sparer and the white space grew. Thanks to my Binder sisters who read and offered beautifully encouraging feedback: Sherine Gilmour (that chocolate was divine), Caseyrenée Lopez, Stevie Edwards, and Emily Rose Cole. My Candle poets, all your burning light. Eileen Murphy, goddess of light energy, thank you for the tarot readings. Love to my first poetry mentor Irena Praitis, who has continued to bless me with her wisdom and who offered valuable advice for this book. Many thanks to poet David Rigsbee for his astute and empathetic eyes and for offering the piece of advice that helped unlock the punctuation. There are so many other loves who've inspired and encouraged me along the way. Please know how thankful I am for you all. And all gratitude to Ross Gay, whose work I adore, for choosing this book. Thank you Blue Light Books, Indiana Review, Indiana University Press, and all my wonderful editors for your help bringing this book to light. As ever, my son Jeremiah and his birthmama for making me a mama to begin with. And my Andrew for everything else.

Girl with Death Mask

Lifeline

From the apartment shadowing our university's
arboretum evergreens taller
than the freeway overpass a girl
we'd crossed in the quad those orange trees
squat & bright from which we picked
a fruit each & peeled them on the walk back
to our one-bedroom pulp in our teeth that girl
jumped She might have floated
I cut off my hair & you hid
the knives for days the bathtub stopper the cords
You told me you were a time traveler
on borrowed time In bed after my diagnosis
& the voices & the voices I could not
quiet you told me you'd come back
to save me & I threw my wedding
ring out the window I didn't
need saving & when we climbed
downstairs you dove into the pool
& emerged from the water like a dolphin
meant to fetch gold bands from the deep
For my slit skin you pricked
your own called us blood buddies
& when the babies started bleeding
down my legs you bought me a doll
from the doll hospital I'd told you
I loved as a kid She came with a birth
certificate & blue eyes Her name was Susan
I threw her at you hurled profanities
How could you have been so cruel
You were not cruel You were a time
traveler We are years later sunset
turning the mountains behind our balcony
watermelon cotton candy pink elephant

I am alive I am alive I am
You'd seen your own death She was a girl
like me She was falling She was flying

I

The Dying Girl & the Date Palm

Come find me under the black persimmon tree Mama
where prayers bear wrinkled fruit bear messages home

Come tend me at sunrise like sweeping
a grave offering fresh tortillas

rolled each morning menudo steaming on the stove
My patch of yellowing in the grass my lungs culling holes

in the sweet so close to my palms I can nearly grasp
What does a mouth hold but secrets What tongue in mine

What bone-handled crotch & tissue paper wadded to staunch
the bleeding The boy on the bicycle called my name pulled

it from my mouth like meat from the seed &
his older brother with a truck A hole in the floorboard

A hole in the world
 Persimmons call themselves stories

of the gods Mama did you also wake into the mythical
I mean raise yourself hold the cast of yourself

bones splitting as moonstones as midnight undone
Leaves fall across my eyes Mama come find me before I bloom

The Change

When I was still small I began growing antlers
as a stag grows antlers as a girl grows
breasts My chest remained flat & the blood
didn't come but the velvet skin
sprang spongy behind my temples No one at school
laughed at the antlers like they did when I'd grown
hair under my arms & razor-scraped my shins
to the blood-bright thrill of the locked bathroom door
Mom said she would've given me warm
water & lotion if I'd let her in The girls asked could I
pierce my antlers like ears or a nose & if they
hurt The boys asked were they strong enough
to break glass crush tin cans & how long
would they grow The doctor
said to stick out my tongue & drink
peach tea from a soda fountain in the nurse's
lounge so I could pee into a cup & prove
myself *Sometimes a female deer grows*
a stub He asked if there was any chance I could be
growing something else I told Mom
there was a boy but it didn't mean anything
I couldn't even use a tampon yet
Soon small red birds gathered & settled
as the velvet turned to bone matured into branches
They were too heavy & I knew I had a choice
Mom scoured every myth required
every curandera crack eggs
over my belly rub sagebrush across
my forehead chant & pray One even told me
to sing I could learn to love my antlers or I could
wait see if they fell off on their own see how long
would they stay gone

Plan B

He held my hand on the ride from El Centro
from the Clinicas de Salud before the morning after

came in a little box like gum at corner drugstores for girls
fifteen & older past the sugar beet plant its smell of dying

frogs like the ones we'd dissected in biology lab
the formaldehyde on my fingers

for days the way lettuce smelled like slicing
or tomatoes little hearts They formed a white

mountain the sugar hulls sweet climbing hill
gated & locked beside alfalfa fields

The desert sky roiled its summer monsoon
irrigation ditches hissing in the broil

I traced shapes in the fogged car window
while he ordered drive-thru two carne asada burritos

& an extra-large Coke I loved him that much
I loved him all the way up that fucking slope & drop

Billiards

It's Main Street
I'm holding a black 8-ball

against the felt of my palm
its heft could dent plaster I've shot

tequila off a baby changing table
in a public restroom I'm

Metropolitan chic
all tight pants & white scarves

blowing across my face
as I strut to the tamale stand

toileting California's tank where I grew up
girls pregnant in high school

or just after with or without
the child's father our parents watching

our kids while we down
gin & vodka in someone's backyard

my man is screwing
someone else in the shed & I swore

I'd never find myself in this mess
but only fear of looking foolish

& pride & the baby
keep me from screaming

I'm not your pinche 1950s housewife cabrón
or breaking cue sticks

across my thigh
I'm trying to remember

it's not her fault nor his We're all
pawns in this game of bullshit

Is this how it is where you live

Quinceañera

1

My body he burned glue-gunning
the papier-mâché of my breasts

to the smell of arts & crafts in the recreation room
(every room after the recovery room)

like the cumbias of my girlhood dancefloors
flailing like Pentecostal Sunday Nothing tasted so good

as the mango con chile from the fruit stand
at the razor-edge of town not even the lime-

squeezed beer its smell of night-
oak shimmering in the yard I'd climb

out my window & Danny with his brother's truck
wasn't the one who squashed

the June bugs spiraling
from my navel my collarbones the peach-

fuzzed skin of my newly-shaped breasts
(girls in alleyways if you survived dumpster-

diving you survived anything)

2

A mother lost her children
to her ex-husband her children with bruises

on their thighs in the apricot-soft
within their elbows photographs the judge ruled

circumstantial or unprovable the wife could not prove
I'm wrecked for a system failing to protect what we love

When I say wrecked I mean the razorblade
I stole when I was fifteen from the hardware store

pressed to my wrists like cat claws
I told my mom were the neighbor's cat's

Mom she's wild she's untamable that fat tabby
(I don't mean wrecked for the women but

unmothered things)

3

 My ex's nana had a stroke
& my ex-nuera Sally told me she asks for me time to time

my ex-railyard familia barbacoa & soaking beans
like I'm never drunk in the grass anymore wailing

like that alley tabby I've never stopped
needing—she lies in bed

between my husband & me stomach pressed
to sheets & waiting hollowed calavera

en Día de los Muertos marigolds
laid on the altar of her belly button

though now she could be my ex's daughter
at *her* Quinceañera in white like a mother in the news

who measured her daughter's growth through
years pressed in a wedding dress from the time

she was a baby God she was too young

4

& fifteen was a good year for me—
In the desert time of Valley ache in that wide bowl

of my hips bone dry asparagus fields crackling
heatwave where I'm still burying placenta fat as hearts

& beating back border roots with my fists
(I told the girl who said this poem is her *one*

chance the doors will shut love in your face love—
knock them down climb the fucking fire

escape) year I first learned to light myself
on fire call the firetruck of my own

body that holiest of waters

Daughter Page Ripped from *The Symbol Sourcebook*

I smudge henna above our bed protect us
from the evil eye rub it on our grassy

cow's forehead in the backyard Sally named me
La Henna as a joke

for how my name sounded in Spanish like I was gringa
until she realized my mama's Mexican too

but the apodo stuck like red rice burnt in the belly

My husband steams the carpets with Fabuloso
purple cleanser Sally once bought from Dollar Store

picking me out dish towels & plastic table cloths
for my all-alone apartment her son wouldn't leave

her house for mine he didn't love me enough

I'm terrified my daughter will turn gourd & fennel
for a boy who'll believe she's no different

than the Maxim- or Showtime-bodied targets
he calls women will hold her head down make her

swallow The springtime smell of Callery Pear blooms
gorgeous white buds that make me gag

I spit on the sidewalk La Henna dripping
bloodstone ghost of a girl who'll shove bezoars

down a daughter's throat to keep her from pulling
worms from the stomach Sex is not a plague

my husband tells me spring cleaning our sheets
flipping our mattress redbrick stains corral-

gates dripping rust relentless in a patch
of spines darling girl I'm sorry the body resigns

Miracle of the River Pig

behold the whole herd of swine ran violently down a steep
place into the sea & perished in the waters

≋

Animals like women are cast in leading roles in plays of
superstition One story if an observant countryman is
right plots the alleged inability of a pig to swim Her sharp
trotters swing so the story goes in circular motion in the water
till she cuts her own throat This the countryman cheerfully
claims did not happen to a sow who awaiting her litter & finding
her sty flooded patiently swam round it unharmed until rescue
arrived

≋

My ex-mother-in-law served me pigs' feet on a plate
her son my madness & I his evil porcine
brewing in the sopa de pat slow-simmered pigs' feet soup

≋

Years ago a young porker fell into an old bramble-covered
well The water level was I don't know some 10 ft down the
water deep It took us half an hour to borrow a ladder & come
back She was still swimming round & round The well mouth
too narrow for a man to go down that she-pig had her forelegs
over one rung her snout under the rung above We raised that
ladder slow The pig held on until she reached the top & we hefted
her up She shook herself grunted & trotted off her throat
unscratched & utterly unperturbed

≋

The boy I met at the swine barns
took me in the piss-yellow straw
& made me suck while the pigs barked
near the dump on the northern tip of town

Look there's the cemetery where I will not be buried
 Will my ex-fisher king be scattered at sea
I will not join him nor be crowned his ex-fisher queen
ex-voto ex-wife ex-plaything

≡—

Down the river did glide with wind & with tide
 A pig with vast celerity

& the devil looked wise as he saw how the while
 It cut its own throat

≡—

Another example of a swimming pig was witnessed in 1946 during
the testing of the atom bomb on the Bikini atoll A total of 3,352
animals were placed around the test site to gauge the effects on
creatures at various proximities to the detonation Pig 311 was seen
swimming calmly in the sea after the explosion & was duly rounded
up & sent to Washington's Zoological Park where she led a normal
existence with no signs of radiation sickness except infertility

≡—

Mama sewed me into a wedding gown
 white as my communion
 when I was uneven in lacey socks & piggy tails

I followed again flint-grey up the river channel
potbellied stones speckling the Río Nuevo

I was that unlucky bride in the river
on the fence border trash
 a little piggy swimming
& the devil inside me

≡

There was no sign of any kind that its throat had been cut In
 fact it was quite lively when being returned to its pen

Ignorance

Nights those Jesus bugs skimmed the creek's surface
my bare feet glimmering like *risen again* I'd snuck

past date palms & horse corrals graveyard
trilling beyond highway & the boys & their shining

bodies I'd brought my own carried it
with me only newer sticky

summer air & white flies circling streetlamps
what bliss was mine those moments before

glistening rocks before shivering water & wet
with what could've loved me could've hovered me home

3-Card Spread What Is True What Isn't True Advice

I am safe I say to myself & pray for mercy
 Ai

1 Trauma

Sponge cradled against wash bin & cracked
Christ I wish it weren't blood I'm t-shirt thread-
bare without pants underwear His name cracks
like thunder frightening my dog to my feet
clouds gunmetal menacing I fly Lovesong
which means Nothing or Failure or Hunger
the electric eel of my body
so sad I know this & carry on What else
can be done Doghouse Makeshift Rusted eye
I go Crazy Again My bare nalgas hanging out
& someone wanting to steal something from me
but I've already reckoned into shards & sifted away
something precious I mean like rubies real
wine-tinged through the desert Red like that

2 Lost Girl Broken In

Spilling like spoiled milk that halfway
house I shimmied down drainpipe half-
primitive in my bike shorts & tube top
down a road half- butchered by potholes
I was half-in love with myself with anyone
who would have me I was strung
to the walls like flypaper though they thought
I was fly in a web I was web half-sex
half-pigflower Lord I was half-hope *who will*
let me in What half-accident turnpike
mistake that glorious half-escape
 still half-unhinging
I am all in

3 The Wilting Field

The last time I had a dick in my mouth I was dying
alfalfa withered in rows unable to separate desire
from pain There are poets for whom this throbbing
is healing My Frida rail-impaled my
chingona fighting for whole even after gangrene
She loved her body though it betrayed
For some of us a dick in the mouth means a fist
in the hair a knee in the ribs a spinal cord
like a clump of pigweed carelessweed splintering
the fingers bright blooms of blood on the skin
Do you take your body wherever you go
Does it follow Someday I'll find mine
dancing in a field without me calling me to join
There is music The crocus is blooming Let go

Daughter Lace Your Fingers to the Sky

Still you could not keep her
from the dance our bodies dance

when we let the boys take us
out to the country

& oh the moon may have been full
& oh the hay may have smelled sweet

as lighted sky & sweetened earth
silhouette backseats

Even through death masks
we can kiss & skin pierces fabric

She let the girls in the stalls & the jeers
in the halls & the *slut*

on the walls twine her neck bones
string her atop a chair

but her dog didn't bark & no one knocked
& God didn't boast of angels

& you mother found her swinging
from the doorframe

1.0 out of 5 stars **Not For Teennage [*sic*] Girls***

*Repeat NOT a book for teennage [*sic] girls. Depressing and innuendos*
*made about sex. Not the manner it's [*sic] which I want my daughter*
to view sex and love.

Published 35 minutes ago by Amazon Customer

It's not what sex & love are supposed to be like
(I'm reliving it again to save anyone else)
 but you know how when your friend tells you
{insert drink} tequila with {insert drink} Pepsi
 tastes disgusting & immediately you're like
Girl let me try & peel her mother's glassware from her hand
while she's making a scrunched lemon face & saying
I'm warning you—it's really bad in a singsong voice
 yeah it's like that {insert sex} {insert love}

*source material for title taken from an Amazon customer review
of a poetry collection marketed for teenage girls

Hallucination with Danny

He dredged mudbound a hole in the sky
he fumbled down partway hitchhiked the rest
from heaven he'd said perched at a bus stop
on Lincoln & Montaño before sunrise
He was beautiful he followed me home
That was back when I was taken by every strange
& lovely creature I found when I believed
in lighting black candles beside
the bed for protection white dust seething
in tinfoil At the particle level inside the packets
of salt I circled around us me & my fallen
angel at the quantum of our bodies inside our
necessary lies everything is random
Flip a coin the coin won't decide
till it's in the air & falling He snuffed those
candles out he burnt down my whole house

What's Been Given Me Secondhand

He bought me a cherry-red dress no a black dress
with cherries stemmed & shining as if bubbling atop
grenadine & syrup with the insurance money he got

for his mama's dying I'd run out of clothes in that
beachfront apartment where his drug friends were letting
us crash we slept in a cupboard the length of his 6'4"

rope-coiled body folded like a robot into a box
a cardboard home for what almost became of me
for loving him too long for loving him at all

Why I always remember him in thrift shops busted
lamps & scraggly rugs piled against walls knockoffs
paraphernalia of longer legs longer days & how often

I miss that messed up man He bought a wedding
band He lost it in the ocean I never asked him
for anything but a razor I hadn't shaved in weeks

a bottle of shampoo I'd never tasted oysters & he said
let them slide down your throat the ones we found
in styrofoam outside the pier eatery but

he wouldn't let me near tinfoil again that white dust made
him so mad coming down & every time I bled he
understood what I was missing The motherless

recognize the childless He said we'd buried something
in the sand Not a castle or a shovel or a bundle of cells
that wouldn't stick that wouldn't grow nothing

so routine Once in a while in a Goodwill between faux
fur & broken music boxes I find him hiding I'm
high enough to believe it his windup his living again

Faithful Woman

Nobody understood her cruelty to herself one would have to
chop off one's own hand to end the source of self-torture
 Marilyn Chin

Tattooed in red clay
his hand prints on my nalgas

while he eats chicharrones con chile
& licks the lemon juice

from his fingers I am
his undesired bride

of fast times bringing
big pots of albondigas to feed his whole

family love utterly

unasked for a belly
filled with sticky red rice

& embryonic fluid
nopales left to soak too long in salted water

at the edge of the valley
sea brined sugar beets

dunes of sand
& towering thunderheads

here is the truth I know

the wanting that aches wildly
What do I know of the ancients

Mama your Jesus failed me
Could he fly

could he wail
could he scrub

the blood-stained trail

Common Carp

I lay in a bathtub of goldfish
unlearning the ways the world loved me
too tight or too narrow bright

as the orange spirals peeling
belly button kneecaps earlobes
I never learned to love back properly

not with my head screwed on my
tailbone switching dangerously how
anything shining has the capacity

for burning I used to worry the water
electric dazzling all the neighborhood
kids chanting *glow glow glow* as I rose

peculiar from the riverbed
lucky as a well-wished copper penny
sinking to a bottom mud like love

Mermaid siren longing song Once
I was glorious What pond what fish tank
ever made me believe that was gone

II

Girl with Death Mask

Frida Kahlo, 1938

She's all over my wall different ages different years

rarely carrying her tagete bloom for laying graveside

en Día de los Muertos I wore a watermelon pink dress

tied at the back when I was a girl & never imagined

the funerals I'd

become

 My daughter

Adelina when I told her

of the bus & pole that metal handrail impaling Frida's belly

(I couldn't tell her where it emerged)

went to the wall & lifted a wooden portrait held

it to her chest & cried *Are you hurt Frida Are you—*

White skull papier-mâchéd to
her face daughter self against
sky Frida I'm afraid in here
It's hard to breathe sometimes

Tiger mask eyeless tongue amok &
jagged teeth Lipstick or blood
smudged like Mama's medicine cabinet
Frida I'm afraid in here It's harder
still being alive

In the book they say you painted this
for fears & guilt about the children
you miscarried they say the landscape
is bleak our Mexican Plateau They
might not hear us Frida behind the
masks They've misunderstood again
that horrible *ojosuaro* they think you
invented *swine's eye* I'm afraid In
here It is always us alone & the girls we
we lost the girls we were the girls we
never—

Sin Vergüenza (Como los Pájaros)

The woman in the documentary reaches her hands
to the fence touches her child through an opening
De mis manos dolor When I was a child my mama
drove me to the swap meet on the other side
for a white dress & flowered wreath my first
holy communion the mamas nursing
on the roadside selling chicle con sus
manos libres Abuelo once rode in the casket
of a trunk He rose again on our side of the border
which crossed Bisabuela's family Look
from my balcony the sleeping sister
volcanoes shaped like breasts I've
thought about leaving Shoving
a duffel bag & laptop into the car taking
the dog But these babies I've wanted since
I was a child That's what girls do where I grew up
down the road from a landfill in the humid stench
of a beef plant & sugar beets hulled & boiled
for their sweet white meat I found an animal in a trap
who'd fought her way through high grasses
wasting to carcass in my own backyard
& I believe you know what a merciful act means
(I don't know the words for the shame I've carried)
The woman in the documentary needs papers
to get back to her children They'd found her
in the hospital without insurance la migra
Mama nursed women who'd run through asparagus fields'
crackling heat bellies full against the barbed wire
they're still burying like umbilicals roots on a battlefield
if the child's a boy or the place where tortillas are made
for a girl Don't you dare say desert
The heat is unbearable & I've seen
them pulling anchors from legs

cursing bullet shells In the hospital facing pig barns
& a graveyard Mama in her scrubs & gloves
pulling newborns bloodied like suicide wrists Jars
of coins for the ferryman & La Virgen burning
an altar on my nightstand Mis manos Mis hijos
Whatever fence I've erected from that salted curse
in my family's blood *Release us*
The woman on the screen whispers a prayer *Fly us*
free as birds Sin vergüenza I admit the darkness
I've swallowed the hollow inside Now who will
unpin our hands & toward sky upraise them

Warn the Young Ones

First war She polishes the spine of her own
flesh Tethered nerve strangling cord She

burial mounds She rituals She
corn stalks in rustling fields Nothing tribe

nothing sex Rock for riverbed Notched
with flint Second war She needs less Sequoia

burns Cities In her body wrappings
of bodies She debates running She debates peeling

skin She stops debating begins praying without
knees Not *for* rain *Prays* rain Holy nothing

unlaces nothing remembered nothing
forgiven— Come others Third war

She is a void in the particle machine She is dust
Fourth war she loses the need for water She loses

all taste Rain brings each earthwormed corpse Nothing
ugly Turn not Her face from the dead She

resurgence She fable of bee boxes
& honey She ark of some lost territory

of animals She zebras She aardvarks
She dredges the flooded streets of her the gutters

Fifth war She grows stronger All that can be
taken she takes All that can be eaten

she swallows All that can be broken she
pulls into her belly & releases Nothing is whole

Sixth war She loses her appetite Her bones brittle
The cabbage in the broth bitters She

pulls from ribcages Hearts Uses them
as weapons Seventh war The cord she began with

Nothing like a noose She would rest Longs for nothing
but rest Each threaded backbone slips its knot Nothing

transforms She wants to tell you this is the end She wants

First Response

The glass jelly jar our small girl squatted over in steam & tile
& peed into I have no idea why that jar was in the shower
but noticed its highlighter hue remembered months
before the smell of another cup on the ledge
This time I ask her why again this strange deed
A boy I heard of lazy or terrified in the night
caught his sunflower yellow in bottles under his bed
dozens of them It feels like that the hoarding
You'd lost your job we'd moved in with my mom
I'd yard-sold all the baby things & wedding gifts
75 cents per plate robin's egg blue & best offer
on the silverware I began to save every jar
the baby food we'd bought with WIC plums
spaghetti sauce peanut butter Once we'd eaten
our fill I fed the dog & the earthworms in my mother's
patch of grubby lawn I emptied like cherries sweet & dark
my own pearled eggs unsticking from my uterine walls
 the other babies I couldn't make
You call this our dusk time We have just enough
She was practicing our girl said for the doctor's how she
couldn't before she had a UTI though she didn't call it that
 We never call things what they are
I've been bleeding into jars each empty night

Sea Level

I've lost most names for things from girlhood
early womanhood can't name the mother
of the man I used to sleep with in her house
she made us nopales prickly pear scraped
the sticky cactus innards into a pan
made Spanish rice & fried beans & his father
had a wooden leg drove a garbage truck
I remember my lover's name so that much
is still true Anthony & I watched prison
break movies had sex in his parents' backyard
house behind his sister's a little house
two rooms a bath a cramped kitchen
that for the few months I nearly lived there
the man I didn't love calling me his
Heina smelled of garlic & onion I've gone
below sea level I'm aching
the prison break of our bodies
Now on the balcony a child's tea set
of brightly colored tin The trees
are blooming again I didn't use condoms
with that man out of prison only months
before I met him I tell my husband
years too late seeking what absolution
facile in the face of my dysfunction
I wanted babies that bad I could have given
him anything My love burns he says
He doesn't mean to hurt me The far road
I've sculled to the end two hundred feet below
a distant ocean below the tall white sugar-
beet plant its sign a line high above marking ocean's
fish-split head a roadmap for how deep I keep
weighing the mistakes I've made I've built
a house of sugar cubes one cube for every

miscalculation what's hidden in my
underwear drawer beneath the outdated potpourri
my mother taught me to keep there
& the sugar castle grew filled the kitchen
heart of the house it lifted the roof when it rained
the sugar melted like Eucharist on the tongue
I was drowning in sweetness

Avra

There are stars I lay down
my body turning

animalia & by that
I mean alcoholic

A woman floats from a staircase
dangling needle & thread

just out of reach

& buttons my ears
my eyes I mean to feel

frightened but haven't
the heart so I

thank her & she hands me
a child

The child laughs
then dies in the strings

of my arms

This is not yet
ghost story but prelude

for how I became both
living & dead

& it saddens me

I dip butter-yellow
wafers into milk

feed them to no one
The woman returns

offers me a zipper
as a promise

to take care of me
& it's rude not to accept promises

I zip my mouth
like a winter coat

the stars have turned to icefields
my hands to bees

Whatever sky
exists does so with snowflakes

& that thought's not as bleak

as what might've happened
had the child lived

one nursery-rhymed morning
its plaything turned *Mother*

like a stuffed hippo
for holding in bed

The trade-off of losing anyone
is love on either side

Failure The Mother of _____

Under the blanket of hard packed
 dirt under cacti cane cholla & palo verde
under the wake of miscarried days
 aborting my entire family under the waterless
storm electric clouds against white sands
 under the holes & pricks those spines
bloodletting under the massive weight
 under the repressive touch of my lover
under my bra strap under my legs
 the child unletting herself again & again
from under my damnable body
 god under it all under all I love I am so alone
& under my loneliness I tumble down
 where the río swells as a balloon begins to rise

Pulse

The bug spray man rings a doorbell
it lingers in the air

black widows fat & hourglass against the redbrick
against tomato vines

boy with bright pink parasol boy across the street who comes
to play with my daughter's dolls

I keep him safe
while the neighborhood thrums

its blacktop its cocking against concrete &
catcalls I remember my own switching down sidewalks

like spotlights boiling orange flowers in the trees
hissing with cicadas & electric wires

cold box my fear
not new this summer

mariposas on their migratory paths
we plant milkweed we swerve ourselves into other lanes

a music tolls not bells
the boy across the street has found a dress that fits

my closet hums
he is humming in my closet his voice is sweet

The Rhinoceros Calf

that failed to make a strong bond with its mother
& was shipped from a Florida zoo to New Mexico's

 (they'd struck a deal with the dairy farm for that baby
would drink thousands of gallons of cow's milk)

that calf in the corner who doesn't know I'm watching her
or thinking anything at all & will remember her for years

will think of her often with her sugared substitute her dry
high desert air & wonder why on the coast

in humidity & hurricane weather in an enclosure
like ours

 & my children sitting beside

me on the bench where I watch tears down my face my
children asking why are you crying mama & the truth

is I don't know did that mother with her body
say nothing say no did that mother really just let go

On Contemplating Leaving My Children

1

I've hesitated beside the bosque deep in the cottonwood
told them *I will not not again*

What sovereign lies What queen in her epistolary cage
An ochre shot glass empties
 a lantern unlit heedlessly shines

In vain I have opened mirrors & edges of mirrors

2

A blanket ripped during sleep a dream turns
cold & the body knows
something is wrong Wake up Wake up!

Traveling flatland winter branches praising a slate of sky
I have passed a shotgunned doe
& known bloodred the dying in me
 would fight back hunter try her might

3

The church nearby the snow is piled high
 Something brightens
in the distance I tread carefully

4

Once I fell into a river but wouldn't drown
 If limbs are made of splintered oars
& hearts of apple blossoms

this world's for me

Mexican Wedding Cookies

We could road trip to Tennessee from New Mexico
the kids & I we could be brave they think I'm brave
we could unroll our bags & throw our chanclas in the grass
we could barefoot it we could unlearn the constellations
& learn them again unhitch their stories from their names
like the names I've taken into my belly & rolled dough
like masa to my mouth through my cervix I've
unbound them I've squatted toward
cement toward asphalt & thick summer air
squelching in my lungs not enough for the work not enough
we could love something ridiculous we could mix pecans
& flour & sugar into balls in our hands then scoop them
onto sheets in the oven sprinkle them in powder
white as that dress I swore I needed we could unbind ourselves
from kitchens from messes from our mama's ideas of what
we need for happiness for luck
for sweetness on our tongues
we could do it I've heard a recipe for letting go tastes
eerily similar to holding on the difference in the butter
or the temperature or the salt in the batter but we know
I'm lying all the things we could & why Tennessee—

Chassis

In Mayan cradle means grave
& grave robbers will be shot
like a curio cabinet formaldehyde-

swollen
 the way my small daughter with sleep
 apnea robs death stops
breathing seven times an hour except in REM

when it's twenty times an hour
 like the woman who said when she was a teen
 found a beer can tab

jagged on the ground she used for wishing
 not to get pregnant before
married— what she rusted over what she split

 I want to tell you why we kill anything
My daughter pretends she drinks blood

on the playground another girl says hers
 is Bloody Mary with celery
a glass with ice clinking cubes

 only I'm hearing pocket knife
against screwed keychain against

wrist (I'm not going to break not against
sandpit) against screwed mother

 daughter why I cannot allow

such leaps She'll have a tonsillectomy the throat
 will open When does it stop
the painful wanting
 to end

⸺

Into the dark body I went into
wells gurgling the way syrup in a wound
& gauze someone tender
wrapped me
 o syringe o bloodletting

no I insist it was necessary
sadness sparkling as river rocks
tiny pebbles jamming the skin
& minnows
 finding homes for holes
is there a monster inside you too the children
ask everyone in the water
the children ask me what I cannot
accept not yet not hours I fight
 the sickness
 O Lord you know what children need
many arms reach (a village a whole seed for planting)
 we climb from the river
mosquitos plucked from calves slit of silver jangle
at my own throat I pulled the cards
& lay them on the sheets black candle lit
between my thighs
 & prayed & prayed & prayed

The Girl (Whose Mother Filled Her Belly with Meth & Let Terrible People Mutilate Her Body Before Killing Her) Runs Away

for Victoria

1

She does not immediately want you to read her story on the front
page of the newspaper at the Walgreens on Universe & Paradise
where you're refilling your living girl's prescription & buying your
girl safe a bottle of crystal blue electrolytes She wants you to
keep your eyes on your girl playing hopscotch across the automatic
doors opening & closing & opening She wants you to pick up a
yellow umbrella to notice the inky splotches of sky forming behind
the hills in the distance She wants you to remember those hills are
volcanoes that they are sleeping & sleeping things wake up

2

When you step into the shower that night you admit you did
look down at the counter & saw two women with their arms
upraised You thought it harmless to keep reading You'll never
know who those women are who needed comforting Because
the caption said what it said about the mother & what she let her
boyfriend do Because you're hyperventilating against the tile
the girl shampoos your hair & sings Her song sounds like the one you
taught her for gathering yourself from the drain like hairs like
colorful strips of paper for the collage you've never stopped working
on She tells you her plan It is so smart she is so smart You
smile as she dips your head back into the warm water and rinses
the soap from your eyes It doesn't even sting the way she does it
She promises she will check on you while you sleep & shows you
the light She promises she will run toward it past the ditches

rusting in the empty desert stretch behind your house & because
you didn't write the story & because she didn't want you to—

3

you believe her

III

La Llorona Comes Over for Dinner

Yo soy como el chile verde Llorona Picante pero sabroso
<div align="right">Chavela Vargas</div>

Sea salt & ache
I've invited her in

as one invites
a distance a dead

relative slow-
loved slow to let go

I've asked her
to wipe

the arroyo water gurgling
from her skirts

hook-eyed fishnet
sinking

My daughter looks
away uneasy

as if she understands
how long

I've longed
for redemption

≡

We've found a recipe for móle (pronounced mol-ay like olé except
make your mouth like you're about to suck an egg)

Oaxaca-style tongue-burnt dark chocolate for pouring on poultry
& she tells me she visits the Midwest now myth has scattered her
like crushed chipotle

like dried thyme & stone-gray ash
she tells me a twister picks up the smell of everything it snatches

what people were cooking chicken grease & garlic
(her children loved allspice sticks of cinnamon they'd line up

like straws or wishbones & split) then that
twister aromatic belly-
full swollen as a bloodblister when it lobs each object down

leaves itself on everything *But it was nothing until it swept us*
 she says
Until it marks us for each other
 I pour us each a drink

≋

My neverborn with umbilical cord
 coiled around her neck tubed motherblood
 turned python

≋

Our bodies brackish
turtle shells
underbellies lacking that tepid padding

those babies who'd sink us young
held like ribcages
& water turning

I tell the woman slicing
tomatoes & spooning white
sugar *I've brought home your*

babies I've fed them I've showered them
their ears filled with fresh cut
flowers their chest bones

stemmed & thorned
She throws me in the river
with her eyes she casts me

into the water drowning
I'm her rancid darling
& she's become the ancient mother

I've daughtered against
the years heavy in our bellies
as stones

≡

While I blacken
 on the dry comal
guajillo chiles ancho chiles chipotle

she toasts the dinner rolls
 & tortilla strips
until they're golden

Together we pour
 our mixtures allowing them
 to soak fully submerged
in simmering chicken broth

 Our talk turns to bedtime stories
She can't believe
 what they're calling her

(babykiller monstermother
 nightterror witch)

so we set aside our spoons
& search

she covers her eyes
 with her braids the lace-white

sleeve of her once best dress

＝

When I was a girl

 something terrible

＝

We decide our favorite picture depicts her
like a Calavera Catrina for Día de los Muertos

dancing with small skeletons who wear paper party hats
boat-shaped beside the río

The manzanita trees are bright & though the artist hasn't shown us
we imagine piñatas hanging

from their branches braced for the children's sticks
La Llorona laughs hollow as papier-mâché

＝

I admit
how she's stalked ditchbanks

wrapped in shadows
children in her rebozo

how some men compare her
with Malinali

our first country's
mother they call

puta traitor whore
like my ex called me

or the neverborns
I lent to the water

Nights I screamed
at my daughter

she ran to me
in fear to pull the monster

from me It's tedious living
up to a legend

We set the table for
we must eat We must eat

what we've saved or waste We
say grace

IV

When I Am Not Joan of Arc *or* You Bring
Me a Bowl of Green & Purple Olives

I am made for our own goddamn kitchen
 I've wrecked us &
cannot light the stove pilot out

& clicking box of casino matches
 my hands juddering Sometimes you carry
watermelon not gently not

to protect it not like a baby & when
 you slice I'm aware of the tattoo
you've sharpied on your forearm numbers

of blood sugar levels correct doses
 of Clozapine & patient names
I need this care the candles you light

my hair caught in the flame remember
 our first unholy apartment
we watched another girl like me

learning to fly We thought
 she was learning to fall
That ledge remember My novice hope

in tarot my resolve in history in 1867
 a French pharmacist claiming
five stoppered bottles contained

the charred bones of my teenage saint remains
 of my maiden You held
my hand as the Catholic church accepted

but the bottles were misplaced
 they were shelved until a forensic scientist
unpinned them from legend

& tested their promise If I were
 the scientist with my white coat & clipboard
I would have done the same

You've assured me I've ruined myself
 with a need for proof A human rib a small
leg bone not human Lord that cat's broken

femur tarred black The bones couldn't have been
 merely burned The scientist found
bitumen pinewood resin gypsum

Embalming They were mummy bones
 Not my sainted girl
schizophrenic heroine but a hoax

I nearly cried when I heard this
 Remember You had to stop me
from excavating my own bones

I wasn't always a nonbeliever Remember
 how I wanted the bones
to belong to the dead girl

Refugio State

Searing into beach as if demented a woman stakes a tent
Does anyone feed the birds does anyone sleep on dirt
A body can survive beneath a pier sea life attaching itself
to the underbelly I am pillared by bilge water a host
of barely visible creatures I've forgotten how to swim
Campsite swabbed of ashes trash a marbled tin pot
of coffee my mother would let me sip grounds A woman
not her no longer anyone I know unrolls a bag
for lying in like a crab atop the sand Did I really fall
asleep here once fat with my daughtered belly
& scorching It's been a long time It's been too long
I've misunderstood I've lost something Geiger me
No one could survive this scabby plankton this unkempt
I slept an ocean of ache & woke & fed the birds that settled

Candling the Eggs

When I first began laying
I hid them in the bathroom cabinet
with the condoms tucked away
in an old makeup bag colors
I no longer wore fuchsias too bold
for parties I couldn't attend &
bronzes that no longer matched
my neck's telltale sunless wilt
its candled milk The depression had
pecked its way into my biology
—tubes blooming eggshell dense yolk lurid
& yellow as my secret But the bathroom
turned rat's hole & the smell
of sulfur would expose me
I couldn't bear
the garbage pile so many
unnamed losses The doctor
had said my body couldn't Husband
had said my broken mind Something
about time But clutch after clutch
they kept coming I bought paper
crates & a large refrigerator kept it
stocked in the basement I began
researching & slowly
identifying with her & her mother
hens cage-battered wing-broken
the work of my body taken &
cracked atop open fires rising
inside ovens I used to love eggs
I used to beat them into cinnamon
& dip stale bread browned
& dripping with syrup I used
to eat them for strength for bone

density for refusing to drop another
wasted ounce into the silage
In a darkened room in a cold dim
place I held a candle to each one
& watched it redden watched
it glow Watched for blood rings
for air sacs for quitters I was hushed
My new luck grew & grew

Bird Bath (Baño de Pájaros)

Leonora Carrington Color serigraph on paper 1974

The nunnery is made of them cutouts
in the rooftops their bodies their wings
the Sisters are turning into birds
with plague masks plague hearts
I call the birds like a lover
in my bed I'm a prayer blinded & turning
into a fountain taunting past a girlhood
of ritual first I needed to find the colors
flat on the wall in the Museum of Latin American Art
first I needed to remember what it felt like turning
pink & the Sisters scrubbing my wide eyes pink
sometimes I still turn into pearl-colored flamingos
before they reach the sea
before the algae that will keep a season of pink
before their mating dances & pairing for life
& flying again streamers peeling away after the party
or brine shrimp falling like petals from the beak
I was bathed in lies I was never that dirty

Ritual

*from 1930–1960 Lysol was the most commonly used form of
contraception*

When I was nineteen I wore Mama's red & black
 crotchless panties then stripped for my first future
husband to the ballad Sweet Child o' Mine I don't know

why she had those slick underwear I only
 know my ex though his mother warned him
not to let his wife act like a slut loved them

& that while I was dancing to the song he'd reserved
 for his daughter I was already losing the Valentine-
red of her
 Mama once poured Lysol in her cunt

like DDT on her strawberry garden I heard her
 pleading with Dad on the other side
of the bedroom door When Dad called her a brick-

shithouse she started dieting swapped tubs
 of smooth white frosting for pink packeted
Sweet'n Lows She thought she needed Dad telling

her she was beautiful though he never would
 When I divorced I ripped apart bittersweet
granules on the desperate pink of my tongue

 like Mama's starched Eucharist or Dad's Prozac
worshipping what we swallow—

Shame

No it's true I put on makeup for my rapist

I loved him I know I shouldn't admit it
the way the wick melts into wax & needs

to be dug out I loved him so hard He still calls me
sometimes I didn't even realize what that night

should be called how naming things calls them
into being I bought a new skirt & I don't mean
before I mean after I even curled my hair

& maybe I'd curl it again I don't know
 how long does it take to be cured They sell

new wicks in packs & you can stick one in deep
with a needle It'll burn the same You can burn
your skin if you're not careful I've done it I've

dreamt I'm not still dead
 I wake on fire

Furiosa

Nobody's going to save you Face it You will have to do it yourself
<div align="right">Gloria Anzaldúa</div>

Not when your limbs are gone not when your fallopian
tubes knotted Not when you've sputtered to a dead end
off the Boca Negra road & the cliff is the only way down
Not when your husband hits you with a brush in self-
defense when you are beating him for your child's screams
Not when you believe there's anything else to believe
Not when you take a knife to his chest & tell him you'll
pull it out that sac beating (for) you & you'll eat it & you
mean it even when the bloodred cords holding you
to the kids (to him) are pulleys & ropes at your throat & he's
holding nothing over you but everything you love
like those bulging rocks black at the mouth of the mountain
that won't ever fall not those ones above your head
painted by ancients by your ancestors (not his) & you
don't hate him but yourself for you keep imagining
something will change

There's a heart in a bag (face it) throw it over
the edge that thing pumping like fury like fire inside
you never belonged to him

Three Wolf Spirits

I watch them paw the air as if even the air
were full with doomed rabbits

What creature in me longs to give in now
& wild

Once I faced in the bottle-
brush in the scrub of dying

leaves a rabbit who didn't run but watched

I swear she watched until I could face her
no longer
Maybe I should seek my fate with the dogs

I've scavenged my way to this place
through times that love is scarce

& sunlight scorches more than it creates
I've faced in the bottle-

rasp of dying
myself & believed those three familiar spirits
pawing at the air

were here for me

In the Waiting Room of the Child Psychologist

My daughter through the door
 her voice a small squeaking thing

 like one of the two mice trapped
in the glass box rusting at its hinges

 in our garden's collection of late-
summer rainwater

When I paid them my last evening vigil
 they were still filling themselves with the poison

my husband left No longer hurtling
 against the trick latch they'd begun

their slow starvation

We might have let them into the sage
 field volcanos rising from stacks of houses

We could have made them our redemption
 in those rocky fields not joke of glass & a desert sky

so clear any mammal might be tempted
 beyond the irresponsible release

 to believe in saviors

We who must know I am not considering mice
 but mothers but the god of all mothers

I fail with so little grace

Reabsorption Elegy

Daughter I won't make milk for you anymore
 The body retreats It reclaims
miracles My smaller-now breasts

shining as with sickness the way the body
 releases its heat a light summer dress floating
in the river while the pregnancy

strips the twenty in Ziploc freezer bags
 their lines fading equal signs or crosses
proof like La Virgen in her robes stains

that didn't freeze or scrape barnacle-
 calcifying silence Some things the body
reabsorbs (split wood fingernails trauma like milk)

Some things it lets go bundles of cells
 that won't grow But not you little girl you clung
& I clung back I used to trick myself

years before you believing my breasts were sore
 & not for pinching If I squeezed long enough
a sticky clear stream would ooze from one side

Look what the body can do
 It can lie I can lie too I'm choosing this
The truth can wrap itself in cabbage leaves or wait

for the body to reabsorb The baby knows
 the difference between milk & mothered cracks
leaking eggshell white & soured

Ghost Girl in the Recovery Room

She points past the empty field
 past the ringing of a church bell She asks who rings

the church bell I tell her no one now

The silverware needs shining
 in the game she's making up She tells me

she is an empty treehouse
 & I am a moon pool

but she's the architect of my scarred abdomen
 she's set for tea It's an ordinary weekday The sound

of bells on rocks or rocks for bells she says

your mother won the heaven lottery
 & had a beautiful daughter I remember saying

something like this to her she's soaked it in as milk to bread

& repeats the beautiful empty of my abdomen She
 scars the moon pool

I am a church bell

I empty past the field past the ringing of play
I remember a table

 It's an ordinary weekday
 The silverware needs shining

Myth

After my salt bath after watching
the evening sky the way one watches

birds I reached for my favorite dress its
slimming V when I saw that its crossed back

had grown a pair of wings I carried it
flapping to the medicine cabinet pulled out

tiny eyebrow scissors & began clipping
like loose threads from a hem only thicker

& wilder Then I slipped the dress
over my head examined my reflection

slowly as a winter fog lifting I turned

The wings Again They were beating
madly & soon I began to fly

My husband was working late
I called to my children but the door

was closed or they pretended
not to hear & I couldn't control

the dress I tried lifting it over my head
but it was stronger & carried me

toward the balcony glass
slamming me again & again

until I unfumbled the latch
 She felt herself much lighter

I said aloud so the dress could hear
The night fell cool Was another woman

watching as I blended into sunset
dipping from sight At last I grew tired

of flying & hunger & cold
I struggled The dress fell onto a field

& I nearly naked beside it

A teenager on a bike lent me his phone
so I called my mother who said

she understood It wasn't just dresses
but any clothing *Once a woman's reached*

a certain age I asked No it was
the night watching she said handing me a wrap

Retrograde

I wonder at the dryer static I've become
the patchwork threadbare clinging—
Maybe the Universe is telling me I'm sticky
Here's a fried sandwich Love a slice
of watermelon plastic silverware
Life's a picnic blanket there are ants Stick around
Letters in the mail like Mama's broken chains
of prayer notes unmeant for me
but maybe they are Here's the address
Come pick me up let's get out of town
let's drive Open a window person
I've never met in person Here's a fresh
pair hang something other
than yourself on the line for a change
One even said there's a light Jennifer
She meant another Jennifer-in-the-dark
You've been drowning a long time Here's air

At the Altar of Staying

A coyote in the road
straddling double yellow lines *no-*

passing flame-blue flickers
against the body's horizon

My mother watches
my small children sleeping

early I drive where sky quilts
mountains black

birds twinning
distance against my mother's face

lines in the road
trash I must resist

peeling roadside
& feeding

at the wick
another prayer

Henna girl you are not the coyote
skirting the edge

feeding fear's belly
ten cuidado ama

the animal in the center is wild
& sweetness

you're tough as tar

This Bridge Called My Back

After Gloria Anzaldúa

He left me at the trial Brujería
I was accused
 Ama in the kitchen there was blood
in the yolk
 I've met one hundred & thirty seven others
I've counted sisters brother femmes
 our singed
bra straps
scars of clotted cream of moonflower searing
 our skin Ama with ironing board for back Ama
with spooled needle for heart & threaded eye
for bed
 We find each other
doorways with henna-stained hands
Ama tell your story
 the way we come back
each spell cast each conjured reprise
 Whatever happened to my body my body kept me alive
 I accused myself tied the rope into a bow
Ama
 take me far take me where the sweet
alyssum & stone memories flower
take me from the stand
& witness
 Whatever happened to my body my body kept me

 Distance lets me love
 myself again

Credits

Gratitude to the editors of the journals in which the following poems first appeared—

"Faithful Woman" (from "The Henna Poems") appeared in *Southwestern American Literature*, Spring, 2011, Vol. 36 (2), p. 71 (5).

"Daughter Lace Your Fingers to the Sky" appeared in *Blood Lotus Review*, Issue 21, August 2011.

"Miracle of the River Pig" appeared in *Goblin Fruit*, Spring 2014.

"Miracle of the River Pig" and "Ritual" appeared in *Mother is a Verb*, Red Paint Hill Press, 2014.

"La Llorona Comes Over for Dinner" appeared in *Yellow Chair Review*, Horror Issue, October 2015.

"Billiards" appeared in *PANK*, Volume 10.6, November/December 2015.

"The Change" (First runner-up for the Jane Lumley Prize 2015) appeared in *Hermeneutic Chaos*, Issue 12, January 2016.

"Lifeline" appeared in *Indianola Review*, Issue 2, March 2016.

"Chassis" (2016 Pushcart nominee) appeared in *Pittsburg Poetry Review*, Issue 3, Summer 2016.

"On Contemplating Leaving My Children" (2016 Pushcart nominee; *Best of the Net* 2016) appeared in *Muzzle*, Issue 18, Summer 2016.

"Avra" appeared in *Thrush*, July 2016.

"The Wilting Field" (First runner-up 2016 *Sonora Review* Poetry Prize) appeared in *Sonora Review*, Issue 70, 2016.

"Ghost Girl in the Recovery Room" appeared in *Foundry*, Issue 1, September 2016.

"The Daughter Page Ripped from the Symbol Sourcebook" and "Failure The Mother of _____" appeared in *Tupelo Quarterly*, Volume III, Issue 10, 2016.

"Reabsorption Elegy" appeared in *Glint Literary Journal*, Issue 7, Fall 2016.

"Refugio State" appeared in *The Journal*, Issue 40.4, Fall 2016.

"Bird Bath (Baño de Pájaros)" and "Quinceañera" appeared in *Queen Mob's Teahouse*, October 19, 2016.

"3-Card Spread What Is True What Isn't True Advice" appeared in *Lifeline*, Glass Poetry Press, 2017.

"Girl with Death Mask" appeared in *National Poetry Review*, Issue 14, 2017.

"The Girl (Whose Mother Filled Her Belly With Meth & Let Terrible People Mutilate Her Body Before Killing Her) Runs Away" appeared in *Wildness*, Issue Number 7, January 2017.

"What's Been Given Me Secondhand" appeared as "Housing Works" in *Missouri Review*, Poem of the Week, February 2017.

"Sin Vergüenza (Como Los Pájaros)" appeared in *POETRY*, March 2017.

"At the Altar of Staying" and "Retrograde" appeared in *Nine Mile Magazine*, Volume 4, Number 2, Spring 2017.

"Ignorance" and "Mexican Wedding Cookies" appeared in *Cincinnati Review*, Issue 14.1, May 1, 2017.

"The Rhinoceros Calf" and "Shame" appeared in *Slice Magazine*, Issue 20, Spring/Summer 2017.

"*1.0 out of 5 stars* Not For Teennage [*sic*] Girls" and "First Response" appeared in *BOAAT*, July/August 2017 Issue.

"Candling the Eggs" appeared in *Maine Review*, Issue 3.1, Winter 2017.

"The Dying Girl & the Date Palm" appeared in *Indiana Review*, Issue 39.2, 2017.

"Pulse" appeared in *Cossack Review*, Issue Seven, Winter 2017.

"Warn the Young Ones" appeared in *Blackbird*, Issue 16.2, November 2017.

"Common Carp" appeared in *Ninth Letter*, Volume 14, Number 2, Fall/Winter 2017–18.

"Plan B" appeared in *Ploughshares*, Winter 2017–2018 issue, Vol. 43/4.

"When I Am Not Joan of Arc *or* You Bring Me a Bowl of Green & Purple Olives" appeared in *Fairy Tale Review* (Charcoal Issue), ed. Kate Bernheimer, Detroit, MI: Wayne State University Press, March 2018.

JENNIFER GIVHAN is a Mexican-American poet from the Southwestern desert. She is the author of *Landscape with Headless Mama* (2015 Pleiades Editors' Prize) and *Protection Spell* (2016 Miller Williams Poetry Prize Series). Her honors include a National Endowment for the Arts Fellowship in Poetry, a PEN/Rosenthal Emerging Voices Fellowship, the Frost Place Latin@ Scholarship, the 2015 Lascaux Review Poetry Prize, the 2017 Greg Grummer Poetry Prize, and the 2015 Pinch Poetry Prize. Her work has appeared in *Best of the Net*, *Best New Poets*, Poetry Daily, Verse Daily, *Ploughshares*, *POETRY*, *TriQuarterly*, *AGNI*, *Boston Review*, *Crazyhorse*, and the *Kenyon Review*. She lives with her family in New Mexico.

31901062650470